SgtJSniper Productions

Informed Annihilation
By John Clements

Copyright © 2014 by John Clements All rights reserved. No part of this publication may be reproduced, distributed, or transmitted in any form or by any means, including photocopying, recording, or other electronic or mechanical methods, without the prior written permission of the publisher, except in the case of brief quotations embodied in critical reviews and certain other noncommercial uses permitted by copyright law. For permission requests, write to the publisher, addressed "Attention: Permissions Coordinator," at the address below.

SgtJSniper Productions Ltd.
31 Linford Drive
Basildon, Essex, SS14 1RZ
www.SgtJSniper.co.uk

Ordering Information:
Quantity sales. Special discounts are available on quantity purchases by corporations, associations, and others. For details, contact the publisher at the address above.
Orders by UK trade bookstores and wholesalers. Please contact Big Distribution: Tel: 01268 551082; or visit www.sgtjsniper.co.uk

Printed in the United Kingdom

Characters List

News Reader

Kyle Langford

Sofia Walker

Waiter

Soldier

Unnamed Officer

Brigadier Charles Davis

Becky the Radio operator

Jimmy

James

Nathan

Tactical team leader

Tactical team Members

Anonymous Hacktivist

Recruitment officer

Prime Minister

Anastasia

Russian Officer

Guard 1

Guard 2

Contents

Table of Contents

Characters List ... 4
Scene 1 ... 7
Scene 2 ... 17
Scene 3 ... 19
Scene 4 ... 24
Scene 5 ... 27
Scene 6 ... 32
Scene 7 ... 36
Scene 8 ... 42
Scene 9 ... 44
Scene 10 ... 50
Scene 11 ... 53
Scene 12 ... 58
Scene 13 ... 60
Scene 14 ... 61
Scene 15 ... 71
Scene 16 ... 73
Scene 17 ... 78

Scene 18	80
Scene 19	82
Scene 20	85
Scene 21	87
Scene 22	90
Scene 23	92
Ext. credits.	100

INT. News studio. BMN News. Day.

Scene 1

On screen is the BMN newsroom with a single presenter behind the table.

> PRESENTER:

Welcome to the six o'clock news, tonight's big stories include the stability of the Syrian conflict, oil prices sky rocketing, and the Egyptian riots continue after the ban on the Muslim brother hood.

With the backing of the Chinese and Russian governments the conflict in Syria have been brought to a major breaking point for the conflict as Britain and the US have committed troops to help calm the situation and put a stop to the chemical attacks. Negations between the prime minister and leaders of the Russians and Chinese have begun while North Korea continues to threaten the United States if they do not withdraw from the conflict in the region…

Zooms out slowly. To eventually show on news on a TV. Zooms out

further to show Kyle and Sofia ruffling under the sheets of a bed. Kyle picks up controller shuts the TV off, and the movement stops.

KYLE:

Happy anniversary Sofia, two year I can't believe it has gone by so fast. I have a surprise for you tonight.

SOFIA:

Oh my god Kyle, it's been two years already, I have had the time of my life with you, I'm so glad I met you, that party we went too changed my life because I walked away with you. So what's my surprise then?

KYLE:

You will have to wait.

Quick transition to later on that evening, Kyle is getting his shirt on and is sat on the bed, while Sofia is in the bathroom.

SOFIA:

Well I hope I'm dressed well for this surprise, I didn't know what to wear.

KYLE:

Well you look gorgeous Sofia, don't you worry

SOFIA:

OK so what time are we leaving?

KYLE:

Actually, right about now, it's not that far to walk…

SOFIA:

OK then.

KYLE:

Right better be making a move then.

SOFIA:

Should I take my coat?

KYLE:

I suppose you should…. but if you don't want to, I have my coat so if you get cold you can borrow mine.

SOFIA:

Don't be daft

KYLE:

OK well, are you ready?

SOFIA:

Yep let's get going

They leave the house and begin to walk down the street hand in hand.

SOFIA:

So where are we going?

KYLE:

It's a surprise honey…. You haven't got long then you'll find out

SOFIA:

Do you know for the time we have been together, you never once told me you loved me?

KYLE:

Oh… erm… well I'm... I'm kind of scared to… I want you to say it first **(he smiles)**

SOFIA:

Is that what you have been waiting for?

KYLE:

Maybe

SOFIA:

Well then Kyle I lo---

KYLE:

We are here

The camera pans slowly to reveal a five star restaurant, it appears to be full with a line out side to get in.

SOFIA:

Oh wow! This place has like a 3-month waiting list

KYLE:

I know, I have been planning this for months now

SOFIA:

Oh Kyle you're amazing

KYLE:

Well after you honey

They enter the restaurant the camera pans across to show the lay out of the building, and then switch to a camera behind the waiter.

WAITER:

Hello, may I help you sir.

KYLE:

I have a reservation under Mr. Kyle Langford

SOFIA:

Wow this place is so amazing

KYLE:

Just wait until you try the food.

WAITER:

Right this way sir.

They accompany the waiter to a table middle of the restaurant Kyle pulls Sofia's chair out for her then tucks her under the table before going down on one knee beside her.

KYLE:

Sofia, you know the past two year has been the time of my life and I have never once gotten around to telling you how I feel... well Sofia, honey I… like you, what am I saying … I. I Love you, and I'm in love with you... you mean the world to me and I hope you feel the same way…

SOFIA:

Oh Kyle don't be silly of course I do I love you so much I have been dying to hear you to say it.

KYLE:

You're amazing, sweetheart

SOFIA:

And you're perfect Kyle.

WAITER:

Are you ready to order?

KYLE:

I believe we are.

SOFIA:

Yes please may I have the house special?

KYLE:

Can I have the same please but can you leave out the peppers?

WAITER:

So that's two house specials, one without peppers, would you like any drinks?

KYLE:

Can I have a pint of your best please?

SOFIA:

May I have a glass of red wine?

After a short wait the waiter returns with the drinks.

WAITER:

Here you are sir, madam. **(The waiter's back is towards Kyle)** Please let me know if there is anything else I can do for you.

SOFIA:

Thank you.

The waiter brushes past Sofia and brushes his hand on her breast.

KYLE:

Watch where you walking there mate!

SOFIA:

It's all right honey just leave it.

KYLE:

It's not all right

The waiter comes back with the food.

WAITER:

I must apologise for earlier, I didn't mean to brush in to you.

SOFIA:

Thank you for the apology.

WAITER:

Well if there is anything at all I can do for you just let me know oh and here's my number to say sorry.

The waiter winks at Sofia and blows a kiss

KYLE:

Oi that's my girlfriend!

WAITER:

Oh sorry I thought you were her brother, either way, keep the number you never know.

KYLE:

You never know what?

WAITER:

Well by the looks of you won't be

long.

KYLE:

I will have you know we have been together for two years now and quite happily as well thank you very much.

SOFIA:

More than happily!

WAITER:

Oh well by the way you dress I thought you were just another Essex whor…

Kyle gets up with a quick movement of his arm and Punches the waiter.

Ext. Bunker. Title sequence. Day.

Scene 2

Quick Fade to a bunker flashing red lights, a soldier saluting as

the door of the bunker is opened.

SOLDIER:

Sir!

UNNAMED OFFICER:

At ease, this has been a long time coming.

The big door closes then the title Informed Annihilation appears on the screen. Brigadier Davis is walking down a metal staircase.

BRIGADIER CHARLES DAVIS:

What's the Situation?

BECKY:

Unchanged sir, the prime minister is still on foreign soil. We are awaiting confirmation of orders sir.

BRIGADIER CHARLES DAVIS:

Well then as you were, let me know immediately of any changes. Oh and could you get me a

coffee………… No make that tea.

Ext. Street. Meeting Jimmy. Day.

Scene 3

Fade to street Kyle is on the phone walking down the street towards campus in front of him is a soldier walking towards him.

 KYLE:

Last night was amazing apart from that idiot but thank you honey, for a wonderful night. I'll see you later on tonight, I'm almost at Uni see you soon, I love you Sofia.

Soldier (jimmy) bumps into him on purpose

 KYLE:

Oi watch where you going

 JIMMY:

You watch it yourself Kyle

KYLE:

Oh Jimmy is that you mate, long time no see what have you been up to?

JIMMY:

Well you know usual marching orders

KYLE:

Oh yeah how's army life treating you?

JIMMY:

It good mate can't complain, tell you what can you do me a favour?

KYLE:

Anything for you mate, as always

JIMMY:

Well it's a bit much to ask, but this case here can you look after it for me, borrowed it off some hot chick.

KYLE:

You're not back to your old ways again?

JIMMY:

Me. What. No. Never **(laughs)**

KYLE:

What is it this time flash or smoke??

JIMMY:

Don't worry just take it back to yours you still live in court road?

KYLE:

Yeah

JIMMY:

Alright then I'll pick it up after I get back; I'm being taken down to Hereford later for god knows what

KYLE:

All right mate

JIMMY:

Just don't open that case in a public area; I know you your gunna be nosy, usual thing don't tell anyone OK.

KYLE:

All right mate, I'll leave it in the usual spot, pick it up anytime.

Jimmy walks away then turns back.

JIMMY:

Actually, listen carefully. I shouldn't be telling you this, I shouldn't even know this but if you're going to be the last person I see before I'm taken away to Hereford then I might as well try and save you, you can't tell another living person, you hear me, swear to me Kyle. **(Kyle nods)** well I heard the Russians look like they aren't going to negotiate and their first target is sunny old England, and our prime minister won't act first, so until he gives us orders we are sitting ducks might as well

be brown bread you get me. Get as far away as possible from prime targets in that case looks to be where that hot chick was headed looks like it won't be affected and it has the safest bunk on this planet, get there tell them you're just following orders, tell them that you have been given the passes inside and to be there for operation FIRST STRIKE you be safe.

KYLE:

But wait...

JIMMY:

No questions! Just do it alright I've got to go, before I get dragged away I have to report to Colchester barrack 10 minutes ago see you on the other side take care and don't lose the bloody case.

Jimmy begins to walk down the street in the opposite direction to Kyle turns a corner and is gone from shot. Kyle then proceeds to walks on to campus.

JAMES:

What took you so long? And what's with the case? Did you hear the news? Last night the reports on that new news channel for the BBC say that we're headed for another useless war, but best of all this time with Russia, you know if that happens we are screwed right?

KYLE:

Yeah I heard something like that, but we are late for class come on time for you to fail

The door slams on the camera

Ext. Army barracks. Welcome to the HQ. Day.

Scene 4

Snap fade to a military base truck door slamming. Jimmy gets

out of a truck.

JIMMY:

Sir, can I ask what I am doing here?

UNNAMED OFFICER:

You can ask but doesn't mean I will answer

JIMMY:

Sir?

They walk in to a hallway with two armed guards

UNNAMED OFFICER:

OK sergeant, I tell you this once and only once you are here under her majesty's official secrecy act, from now on anything you see or hear you don't talk about, you're not to utter one word, do you understand? If you do you and your family and anyone you have ever known will disappear understood?

JIMMY:

Sir!

UNNAMED OFFICER:

You must sign this before you can enter, but of course, you don't have to you could always walk out of the door you came in… but I must mention if you do, you are trespassing on a secret facility and are liable to arrested or worse depending on how these two guards assess your threat level.

Jimmy signs the paper work

JIMMY:

So sir what am I doing here

UNNAMED OFFICER:

Well son you're now a part of BNC short for British nuclear council your job now is to, without question or thought, make sure the button is pushed and the keys are turned. This key you will not lose you are a member of a two man team the other of whose identity even to me is a secret you will be a part of an immediate action team should the

countries threat level reach critical.

JIMMY:

Sir yes sir

Int. Kyle's house. Home from Uni. Day.

Scene 5

Fade out to male walking in to his house.

Male walks into kitchen place bag and coat turns TV on and proceeds to the bathroom as he begins to undress the camera pans to the TV in his room and zooms in

On screen is the BBC newsroom with a single presenter behind the table.

PRESENTER:

Now as long as I lived I hoped never to give this message, the negotiation with Russia have failed, the United Nations are at war with Russia I repeat Britain is at war with Russia. The public have been warned to brace their selves and all of our reserve forces are now under military law section 11b unless you are unfit for duty report to your local TA or armed forces base or recruiting center …… pssss

Three loud beeps are heard, and then one long bleepBBC symbol is shown on TV

PRESENTER **(voice over):**

This is BBC television from London normal programing has been suspended…This is BBC television from London normal programing has been suspended…

Loud beep is heard

This is an emergency broadcast from the BBC information of a possible nuclear strike has been

received the current threat level is critical meaning an attack is imminent civilians are advised to stay in their homes. Evacuations are currently taking place in the London area. All motorways and airports are closed to the public for military use only non-essential telephone lines have also been suspended. Please stand by and await further information.

Loud beep is heard

This is an emergency broadcast from the BBC information of a possible nuclear strike has been received the current threat level is critical meaning an attack is imminent civilians are advised to stay in their homes. Evacuations are currently taking place in the London area. All motorways and airports are closed to the public for military use only non-essential telephone lines have also been suspended. Please stand by and await further information.

Warning. Warning… Attack level critical ……warning……….warning…seek immediate shelter…. Warning. Seek immediate shelter

Timer on screen 1:30:49:049

Kyle jumps out of shower and runs to the TV

KYLE:

This is bull shit can't be real.

Turns the channel a few times it's the same screen

KYLE:

An hour and a half! What the hell! I got to save my girlfriend, oh and my mates shit

He runs to his room chucks on some clothes and sees the case, He opens the case and inside is a hand gun

KYLE:

Shit ... well I might be able to use this

He looks out of the window.

There is a police officer rushing towards a car (keys drop just in shot but not noticeable) officer reaches into his pocket for keys can't find them he proceeds to

break into the car drives off

　　　　　　KYLE:

What the hell this can't be happening

TV playing hiss flashing in the background with warning siren

Kyle goes out and begins running up the street to his friend's house.

He sees a car, pulls out the handgun form the case just as the car pulls over, the driver gets out and runs into a house leaving keys and car open and engine running.

　　　　　　KYLE:

All my life I dreamed of being in an action movie where's a camera when you need one this shit make money!

Kyle gets in the car and starts driving towards his friends

INT. James house. Saves the friends. Night.

Scene 6

Kyle gets out in a rush with hand gun in hand across the street he see what looks like youths rioting and stealing objects from a store window Kyle runs into a house cut to straight to shot in the room.

KYLE:

Guys listen we haven't got long you heard the news last night, well we have less than an hour to get the fuck away from here, and we are at nuclear war with Russia!

JAMES:

Calm the fuck down it's only a game!

KYLE:

I'm not talking about CoD mate!

This is real, look jimmy our mate in the army he gave me a gun and I just saw a police officer steal a car and drive off and then a riot in town we need to leave!

Kyle pulls the Xbox to the ground

JAMES:

Oi I was bloody playing that you owe me a new Xbox!

KYLE:

I won't owe you bugger all if the nuke lands near here mate

JAMES:

Right you're telling me we are at war with Russia

KYLE:

Mate we are at nuclear war! Listen

Kyle turns on TV it plays warning it's a repeat of the news and Kyle then turns the TV off

JAMES:

Right, so I guess I should assume the position place my head

between my legs and kiss my arse goodbye?

KYLE:

We are getting as far away as possible let's go

JAMES:

So your idea is to get you and me out of here by driving and out running a nuke are you fucking insane?

KYLE:

Of course I'm insane I want to live now let's go

They exit the building and rush to the car fade to outside

JAMES:

Where did you get that heap of shit?

KYLE:

Does it really matter?

JAMES:

Not really just does it drive?

KYLE:

No I pushed the fucking thing round here didn't I

JAMES:

Well it kind of looks that way

NATHAN:

Hey guys, towns like well busy can't even get in to the shops or nothing.

KYLE:

We have to get out of here we are at NUCLEAR WAR WITH RUSSIA!

NATHAN:

What! Don't we like, have an army or stuff? Shouldn't we be like getting a gun or missiles anything?

KYLE:

We are getting out of here; we need to get in this car NOW!

NATHAN:

So I see two seats in the front-

JAMES:

Shotgun

NATHAN:

What I was just about to say that, well where am I supposed to sit?

KYLE:

Well it's a car not a two-seat dodgem you can sit in the back

NATHAN:

Oh right I see doesn't matter that I have travel sickness then

KYLE:

Are you fucking kidding me of course it don't matter we just need to get as far away as possible

They all get in the car and the car drives away

Int. War room. Night.

Scene 7

Cut to a screen in the war room

BRIGADIER CHARLES DAVIS:

OK lads, this is what our ridiculous government salary has

been preparing us for, I want you all to know if the code comes through verified from the prime minister you are all to act without question is that under stood!

WHOLE ROOM:

Yes Sir!

BRIGADIER CHARLES DAVIS:

That's fantastic lads now: STAND TOO!!

The room packs with activity the radio operators organising fire strike orders for nuclear subs and preparing strike packages for stealth fighter bombers

BECKY:

Flight team alpha one zero proceed to sector niner two

PILOT (voice only):

Received over

BECKY:

Base team Charlie six niner, message over

CAPTAIN (voice only):

This is base team Charlie six niner, go ahead zero

BECKY:

You are to position yourself for PROJECT FIRST STRIKE is that understood

CAPTAIN (voice only):

Base team Charlie six niner, understood standing by for authorization

BECKY:

Base team Charlie six niner, this is zero wait out. All stations this zero, message of high priority from brigadier Davis standby to receive over.

(Radio silence)

BRIGADIER CHARLES DAVIS:

This is brigadier Charles Davis you are to carry out operation FIRST STRIKE our allies have given control of all units this is a united force and under

authentication from myself you will carry out your fire mission until death or given your individual stand down authorization all station confirm.

(Radio silence) As the voices erupt over the radio the room begins to get increasingly busy and the camera pans until the table is in full view in the center. The radio communication is headed loud and clear on the overhead speakers.

BECKY:

This is zero understood!

MULTIPLE VOICES:

This is alpha understood
This is alpha one zero understood
This is alpha two zero understood
This is alpha three zero understood
This is alpha four zero understood
This is bravo understood
This is bravo one zero understood
This is bravo two zero understood
This is bravo three zero

understood
This is bravo four zero understood
This is Charlie understoodThis is Charlie one zero understood
This is Charlie two zero understood
This is Charlie three zero understood
This is Charlie four zero understood
This is base team alpha four niner understood
This is base team alpha six five understood
This is base team alpha seven two understood
This is base team bravo three six understood
This is base team bravo four eight understood
This is base team bravo niner niner understood
This is base team Charlie fiver seven understood
This is base team Charlie six niner understood
This is base team delta four

eight understood

This is HMS FORTLOIN understood
This is HMS GRAVELPLATE understood

This is HMS JAVELIN understood
This is HMS NORTALS understood
This is flight team alpha leader ready and understood
This is flight team bravo leader ready and understood
This is flight team Charlie leader ready and understood
This is flight team delta leader ready and understood

BRIGADIER CHARLES DAVIS:

This is brigadier Davis received over

BECKY:

All stations this is Zero I have control standby to receive orders wait out.

Continues to get busy with maps and radio communication

JIMMY:

Sir

BRIGADIER CHARLES DAVIS:

Yes Sergeant

JIMMY:

Is this some kind of drill?

BRIGADIER CHARLES DAVIS:

If only it were my son, this is the real deal I wish to god this was a drill, but I'm afraid it's all real the warning went live before even I was informed so we now are taking action to find the source of the alert but until such time we are now in lock down the only person that can order us to stand down is the prime minister himself.

Ext. How far do we go? Night.

Scene 8

Cut back to in the car

JAMES:

So how far do we have to get, so this doesn't affect us? Whatever this is.

KYLE:

Well the epicenter will have a 10-mile instant kill zone, 25miles from that will have blast and heat damage, and a further 15miles affected by radiation so 51 miles is safe enough.

JAMES:

How do you know this shit?

KYLE:

Well you know jimmy, the soldier that used to come round a lot when we would have Xbox marathons, he and I applied for the army at the same time jimmy applied to be a combat soldier a grunt as it were, well I kind of did the same but I asked for a more intellectual role, well half

way through my recruitment I was approached by a no name officer, said he wanted me to do some kind of job if I was successful in my interview, he said it was a high action role but involved more button pushing that your average grunt, I stupidly said why not after coming out of my interview job offered I went to find Mr. no name and he had vanished no one there knew who he was or where he'd gone. So I left and began my journey home, anyways few minutes down the road this unmarked blue car like the one we are in comes screeching down the road in front of me pulls up beside me and then I get a black sack on my head.

Ext. The flash back. Day.

Scene 9

On the bridge.

 KYLE:

What, what happening, help me what's happening!

RECRUITMENT OFFICER:

Shut it, drive, drive, drive

UNNAMED OFFICER:

Alright, here's the deal you keep your mouth shut or you're going to have nice new hole to breathe with in your chest

KYLE:

Where you taking me?

RECRUITMENT OFFICER:

Didn't you hear, we said shut it

Hits him back of the head

JIMMY:

Get ready

UNNAMED OFFICER:

Go, go, go

RECRUITMENT OFFICER:

Move it

Dragging Kyle out of the van in to a building

UNNAMED OFFICER:

Put him over there

JIMMY:

Can I do it this time?

UNNAMED OFFICER:

Alright, ribs, arms and legs nowhere else not yet

JIMMY:

Punches Kyle in the ribs

What's your name?

KYLE:

Arghh! Shit that hurt, Jake

JIMMY:

Punching Kyle in the stomach

Where do you live?

KYLE:

Arghh! Your momma's house

JIMMY:

Punching Kyle in the left side of the ribs

You what! Where do you live Kyle?

KYLE:

Arghh! How do you know me?

> JIMMY:

Punching Kyle in the right side of the ribs

I said where do you live?

> KYLE:

Arghh! I live inside your sister, didn't you hear she likes it all night long

> JIMMY:

Punching Kyle above the knee

She's 6 years old you prick, what's your job? If you lie to me this time I might have to chop off that one-inch wonder you call your dick

> KYLE:

Errmh! I work for your mum I'm her toy boy

> JIMMY:

Sir! I think he's ready

> UNNAMED OFFICER:

All right then, tie him to the chair and put him in the light

RECRUITMENT OFFICER:

But I didn't get to do my bit!

UNNAMED OFFICER:

Don't worry I got lots for you to do

RECRUITMENT OFFICER:

But I had my bucket and towel ready

KYLE:

Please no more

They move him in to a bright light in front of a table

UNNAMED OFFICER:

Well Kyle, are you thirsty?

KYLE:

Wait, I remember your voice you were at the recruitment office for my interview you offered me a job.

UNNAMED OFFICER:

Well done Kyle you recognise 1 of us but who are we?

KYLE:

And the guy that kept telling me to shut up it's my recruitment officer

RECRUITMENT OFFICER:
Oh bollocks he recognises me

JIMMY:
Well one more son and you got all three

KYLE:
And jimmy has a 6 year old sister so is that you jimmy

UNNAMED OFFICER:
Well now that you know who we are. Do you remember what I offered to you in the recruitment office?

KYLE:
Some sort of job

UNNAMED OFFICER:
Give the man a gold star he's on fire

KYLE:
Wait I still don't get why I just been beaten to within an inch of

my life though

> UNNAMED OFFICER:

Sorry Kyle just needed to make sure you wouldn't talk under interrogation, you understand right

> KYLE:

Why's jimmy here then

> UNNAMED OFFICER:

Same reason you are he just got out of his beating

Fade back to car

Ext. Inside the car. Night.

Scene 10

Inside the car.

> KYLE:

Yeah so my best mate had just joined in this beating on me and done me over to make sure I wouldn't talk under pressure, because I knew anything right

JAMES:

So these guys beat you up, just to make sure you wouldn't talk, fuck that for a game of soldiers

KYLE:

You have no idea, so anyways these guys did this and then explained to me that because I did bio nuclear chemistry at university and was passing with the highest grades seen, they wanted me for 'project FIRST STRIKE' Jimmy also had a job offer a more security version of the job I was being offered but once it was explained to me I turned down the job.

JAMES:

Whoa, I've heard about first strike it's on my game

NATHAN:

Yeah your right 'Project FIRST STRIKE' is the operation undertaken by all country leaders it's for if and when they get ready for nuclear warfare, the

project is a last stand order for the button pushers and leader's in which they assess the early warning system and the threat level of other countries. The people that enact that order become ready to take action if the prime minister or president suspects the enemy of a possible attack and that after the decision is made we have the first strike.

KYLE:

Exactly but this would be a secret, and the public wouldn't get any information, the fact we are running from this attack is the work of 'anonymous' **(both Nathan and James look stunned)** a hacking organisation that is intent on making the information we are entitled to known public. So when the orders were issued they activated the alert. Jimmy gave me this case it says MI5 on all the documents he took it of some woman and told me to follow the orders inside to save myself now I'm saving you.

Ext. The tactical team. Night.
Scene 11

Fade to flats with tactical squadAs the camera fades in and down to a squad of highly equipped men in all black the camera hits the floor and red high heel shoes are in shot the camera slowly moves up the legs which are exposed up until it reaches a suit dress above knee height Camera switch focus on to the map held up on the back of one of the men.

SOFIA:

Voice heard but not seen

Right boys, listen up we have traced and counter traced the signal for the false alert to this building you will enter with extreme caution. But I want it to be quick; I want it so quick the cockless twats that pulled me

away from my boyfriend won't know what happened. You have lethal authority but please try to keep this prick alive I want to personal put my heel through his ball sack.

TEAM LEADER:

Yes mam, Right you heard her boys we will attack this block, straight up the stair well, we believe the person reasonable for this alert is in this flat, remember this is a hacker so expect cameras expect our power of surprise to be compromised with even the slightest wrong turn. We will be taking out the power for 10 seconds just enough to knock the cameras out, so we will have just over a minute to make it up the stair well, after that any cameras will need to be taken out ghost style understood

ALL MEN:

Sir, yes, sir!

TEAM LEADER:

We will breach the door and then

clear the rooms. And boys unless you want size 9 heels in you knackers try to keep targets alive, but don't take any risks if they become a treat eliminate them.

Slight pause camera looks at the laptop on top of the car bonnet watching live feed from the camera the camera goes dark then fusses out.

TEAM LEADER:

Right boys load up, lock, stock and try not to smoke your barrels!

Camera follows as they kick the front door in and they rush up the stairs, they reach the landing and stack up on the door they place a charge and then the camera zooms out.

TEAM LEADER:

GO! GO! GO!

There is an explosion as the door is taken off its hinges and lands on the floor. The men rush in the camera turns to see the

mysterious women walk up the stairs with a handgun in her right hand.

MAN 2:

Room Clear

MAN 3:

Clear

MAN 4:

Clear

TEAM LEADER:

Target is secure mam!

The woman walks in straight up to the computer past the men and the tango on the floor. And types in a few things on the computer and few sounds are heard then the computer dies.

SOFIA:

Into a watch on her left arm

This is agent Sofia walker; signal source shut down operation public silence complete sir!

Brigadier's voice heard with

slight muffle as it is received in an earpiece

 BRIGADIER CHARLES DAVIS:

Well done you can always count on MI5 to do their jobs, no loose ends agent, once you have dealt with this you and your team are needed for close protection of the prime minister on his way to the bunker, you will meet him in Europe.

 SOFIA:

Understood

 ANONYMOUS:

We are anonymous we will not be silenced we will be heard we are coming, expect us!

Sofia steps on the man's nuts with her heels and twists her foot, and then point the gun towards his head.

 SOFIA:

My boyfriend may die because of your idiotic actions; I know I can't save him now. So this is

for him you dickless fuck.

Gunshot heard as camera outside of room sees the man's head it the floor and the flash just before.

INT. WAR ROOM. NIGHT.

Scene 12

The camera fades to the war room.

BRIGADIER CHARLES DAVIS:

Right boys, the warning signal is cut the public are now blind we need to send the call to the news rooms around the country to call it a hoax.

JIMMY:

But sir does that mean we can stand down if it's a hoax.

BRIGADIER CHARLES DAVIS:

Listen up son, we have been called because our prime minister is on foreign soil with the threat of possible war, the public would have a hard time

understanding that only the best and brightest are to be saved in the event of nuclear war, so if negations fail we will get the call I have been waiting for my whole life. Until we are given a direct order to stand down by the prime minister himself we will do our job.

JIMMY:

But sir what if the prime minister can't get out of the situation if the negations fail.

BRIGADIER CHARLES DAVIS:

I as the highest-ranking officer in charge of the last stand ordered by the prime minister will act on my duty after 5 hours silence from the prime minister escort.

JIMMY:

Sir, yes sir

BRIGADIER CHARLES DAVIS:

Just do your job and the others

will do theirs as well?

JIMMY:

Sir!

INT. BMN NEWS. Night.

Scene 13

Cut to a BMN broadcast of the hoax call

PRESENTER:

This is Jamie Redford for BBC London news breaking news the recent nuclear attack threat is being reported as a hoax, yes a hoax the Hacktivist anonymous are said to be responsible for activating the nuclear alert and threatening the lives of millions as they began the panic all over the country. Police and government authorities are saying the persons responsible have been dealt with and that during a raid on the tower block in north London it is believed the Hacktivist took his own life police are reporting that an incident of this nature has never

before been seen but are warning the public to stay indoors to try to calm the nations panic levels…

Ext. The car loses fuel. Night.

Scene 14

Fade to car.

KYLE:

Shit! Shit!

JAMES:

What's wrong mate

KYLE:

We are almost out of petrol

JAMES:

Shit what we going to do

KYLE:

There is a garage just up the road, hopefully there will be some petrol there, we will stop there and if there isn't too much panic we will grab what we need

and go

NATHAN:

And what if there is what then

KYLE:

I don't know

NATHAN:

So we risk getting our heap of shit of a van, while we pick up tampons and fuel

KYLE:

Just shut up OK I have this **(brandishing the hand gun)** if things go tits up.

JAMES:

Shit man put that thing away

KYLE:

Listen desperate times call for desperate measures, we do what we need to you get me

JAMES:

Ok do what you have to but don't kill anybody ok

KYLE:

All right, keep knickers on

The car pulls in to a petrol station in the middle of nowhere there are many abandoned cars and no sign of the owners.

KYLE:

Shit it looks like a riot or something cleared out this garage, **(Kyle has gone power mad with adrenaline and starts saying things in a mad hushed tone)** see this is why panic buying at Christmas time is bad you know too much pressure to buy and not enough product for everybody! **(Back towards Nathan and James)** let's just hope there's fuel in them pumps we are in and out of here in less than 5 got it you're not back at the van in 5 minutes I leave with or without you got it.

JAMES:

Five-finger discounts never sounded so good

NATHAN:

What in the world is a five-finger discount?

JAMES:

Don't tell me you never heard of a five-finger discount, it just means to pick it up and walk out of the store.

NATHAN:

Cool well then grab everything then.

KYLE:

Don't be stupid just get what you need, no more.

JAMES:

See you in five

James and Nathan get out of the car and walk in to the Garage as Kyle gets out and begins to look for petrol to fill the car up he takes a good look around and

notices that around the garage there is a lot of litter as if people just dropped what they had and ran. He finds a jerry can filled with petrol and begins to fill the car up he rattles the can in the car and then throws the jerry can away. Fade to inside the Garage.

JAMES:

Nathan have you got what you need I have just about everything I can carry

NATHAN:

Man I'm loading up this here carrier bag and I'm just about to get us some money

JAMES:

What in the world are we going to do with some money? we are about to be hit with nukes from the motherland herself and your collecting money! It's more likely to be bottle caps we use as a currency than the queens own pound.

NATHAN:

Yeah well I'd like to remember this world a rich man and I think this here till will give me all I need. **(He smashes the till and the draw pops open.)** See easy as 1 2 3.

JAMES:

Whoa, calm down mate.

A man walks out from the door behind the counter brandishing a gun.

DAVE:

Hope you boys are planning on paying for all them fine items you have there and I hope you broke that till by accident I wouldn't want to put a blood stain on my nice clean floor.

JAMES:

Please don't point that at me, we just came in to get some supplies you know we are about to get nuked.

DAVE:

It a bloody hoax, isn't no way

our government would tell us shit about it till it's already happened.

JAMES:

No man it was on the news and stuff let me turn on that TV and I will show you, what I mean.

DAVE:

You move and I blow you bloody brains out

NATHAN:

He's telling the truth it isn't a joke just let him turn on the TV

JAMES:

Please I have money for the supplies.

DAVE:

What about the petrol?

JAMES:

What petrol?

DAVE:

The jerry can that was outside I saw one of you take it, what you try taking me for?

JAMES:

No I'm not trying to muck you about, I dint realise we had taken the jerry can; I have money just let me turn the TV on and I will show you.

James touches the TV and Dave fires a shot into it.

DAVE:

What did I tell you move and I blow your fucking brains out?

Outside Kyle hears the gun shot and quickly makes for the door. The camera follows Kyle as he approaches the window and sees Dave holding James and Nathan hostage Nathan makes a break for the door Dave shoots him in the leg. Kyle at this point runs in and bursts through the door thinking Nathan has been shot dead Kyle doesn't have a second thought as he brings the gun up and shoots Dave three times repeatedly in the chest.

NATHAN:

SHIT! MY LEG MY FUCKING LEG!!!

KYLE:

I thought you just died thank fuck your alive, James help me carry him to the car.

They pick him up screaming and drag him to the car Kyle and James run back into the Garage and grab all they can carry Kyle leaps over the counter and grabs the first aid kit hidden under the counter.

KYLE:

We need to get out of here and bandage his leg

JAMES:

What the fuck was that in there.

KYLE:

Just shut up get his leg sorted out let me think

JAMES:

You just killed that man

KYLE:

I thought he killed Nathan all right I was sure he was going to kill you too I just saved your life now shut up and deal with Nathan.

Kyle turns on the car and wheel spins it out of the station.

JAMES:

It's just a flesh wound mate you'll be fine just sit tight here's some paracetamol take two and let's keep soldiering on ay.

James rubs starts to rub Nathan leg

NATHAN:

Easy... for you... to say… you didn't get shot in the leg! And stop rubbing my other leg

JAMES:

Your fine take these, were almost

there

KYLE:

Yeah mate almost home free.

Ext. European meeting. Day.

Scene 15

Fade to black car zoom in through the window to find a dark figure and Sofia.

SOFIA:

Mr. Prime Minister, I'm Sofia walker your escort to the BNC's HQ for the debriefing as I understand the talks went well?

PRIME MINISTER:

They did indeed, we have a cease-fire and peace treaty with Russia and their allies and Syria will now have a joint effort from us and them to bring the chemical attacks to a Holt and to help the people and to bring the civil war to a stop.

SOFIA:

So can I send the stand down order for project first strike sir?

PRIME MINISTER:

Yes of course, please do and let them know our E.T.A, I'm rather tiered.

SOFIA:

Glad to hear it sir, we will deal with the stand down, **(into radio)** this is agent Sofia walker MI5 I am with the prime minister on our way back home E.T.A 2 hours this is a full stand down order, I repeat stand down we are at peace.

PRIME MINISTER:

Glad that's all over I would have never be re-elected if we went to war, I'm rather fond of my job, so tell me Sofia, how did the public get informed of this nonsense anyways.

SOFIA:

A global Hacktivist division known as Anonymous, the source was shut down at the source

several hours ago sir.

Int. Zero hour. Night.

Scene 16

Fade to bunker.

JIMMY:

Sir did you hear that

BRIGADIER CHARLES DAVIS:

Yes I did, and no one here will stand down understood!

JIMMY:

But sir that was the prime ministers order we are to stand down!

BRIGADIER CHARLES DAVIS:

No all I heard was a stand down order from a woman no doubt a Russian spy we will not stand down, is that understood!

JIMMY:

Into radio

Hello Sofia this is sergeant jimmy Waynesfield, can you repeat your last and can you….

Brigadier snatches the radio.

BRIGADIER CHARLES DAVIS:

There is no radio communication unless authorised I said she is a spy and that is all sergeant.

Listen up very carefully lads it has been more than five hours since we last heard from our prime minister….

JIMMY:

That's a lie we just had our stand….

The brigadier punches jimmy in the stomach

BRIGADIER CHARLES DAVIS:

Guards take him to the holding cell to cool down

JIMMY:

This is wrong and you know it! You open the door to the silos and it's all over you will cause world war three.

BRIGADIER CHARLES DAVIS:

Then so be it, but my prime minister has not given me the stand down; nor has he given it to any of you. Guards take him out of here immediately.

Under project first strike I am giving you the key holders executive override code for non-parliamentary action. ALPHA NINNER TWO ZERO CHARLIE OSCAR. You are to authenticate this action and act under military law all that fail to abide by this will be held as traitor to the country and executed as required do you understand!

WHOLE ROOM:

Sir yes sir!

BECKY:

I authenticate this action BRAVO EIGHT THREE NINNER DELTA UNIFORM.

BRIGADIER CHARLES DAVIS:

My code is niner five niner one zero three all stations I now have control this is not a drill I repeat not a drill there will be no stand down understood.

ALL STATIONS AS BEFORE:

Understood fire action indicated

BECKY:

Countdown commenced, launch in 1 minute.

BRIGADIER CHARLES DAVIS:

God Save the Queen and god save our souls.

Outside the guards are escorting jimmy to a cell jimmy bends as if in pain in the stomach

GUARD 1:

Keep moving, haven't got all day

JIMMY:

I feel kind of ill. My stomach hurts

GUARD 2:

What's wrong?

GUARD 1:

Does it matter get him in the cell then we will find out, not like he is going anywhere anyways

They both approach him, he moves to the right grabbing guard 1 by the neck snapping it instantly guard 2 struggles with him until finally the gun goes off and kills guard 2.

Jimmy rushes back into the room.

JIMMY:

WHAT HAVE YOU DONE STAND DOWN SIR OR I WILL DROP YOU WHERE YOU STAND!

BRIGADIER CHARLES DAVIS:

Son you don't have the guts, and any way it's too late the codes have been sent it's all over!

JIMMY:

Stand them down now!!

BRIGADIER CHARLES DAVIS:

Even if I wanted to there is no way first strike was designed to be a final decision.

Int. Russian bunker. Day.

Scene 17

Flash fade to a similar building outside. Russian soldier running with files towards the door pulls out a swipe card and runs into a small room with a control station and a few monitors.

ANASTAISA:

Сэр, Великобритании просто пошел ядерного, все бункеры загрунтовать и направленных для нас и наших союзников, сэр **(Russian)**

Ser, Velikobritanii prosto poshel yadernogo, vse bunkery zagruntovat' I napravlennykh dlya nas I nashikh soyuznikov, ser

(pronounced)

Sir, Britain just went nuclear,

all silos primed and aimed for us and our allies, sir

 RUSSIAN OFFICER:

Что! мы только что подписали мирный договор с ними, вы уверены!

Chto! , my tol'ko chto podpisali mirnyy dogovor s nimi, vy uvereny!

What! We just signed peace treaty with them, are you sure!

 ANASTASIA:

положительные сэр! Что я должен делать?

Polozhitel'nyye ser! Chto ya dolzhen delat'?

Positive sir! What should I do?

 RUSSIAN OFFICER:

у нас нет выбора, нанести ответный удар теперь все силы на наших врагов без пощады!

U nas net vybora, nanesti

otvetnyy udar teper' vse sily Na nashikh vragov bez poshchady!

We have no choice, strike back now all force upon our enemies no mercy!

Ext. The prime minister. Day.

Scene 18

Fade to black car. Sofia is holding her ear as a message comes through

SOFIA:

I have just been informed our country went nuclear sir

PRIME MINISTER:

What! How, why, when?

SOFIA:

a couple of minutes ago sir and the Russians aren't taking this as a drill they're saying that we have betrayed them and they will no longer uphold the cease fire

death to all our enemies, sir they have retaliated, we have no chance to negotiate, we are at nuclear war!

PRIME MINISTER:

May god be with us, what's the estimated impact time? How far until we reach British Soil?

SOFIA:

Sir we aren't going to Britain we are to remain in Europe in a secret bunker with our allies we have less than 1 hour until impact

PRIME MINISTER:

Under the circumstance I believe Europe is our only choice, inform our allies we will not go down without a fight.

SOFIA:

Sir all communications from us have been overridden by the brigadier in charge, we have no way of contacting anyone until after we arrive in the bunker. I'm sorry sir.

PRIME MINISTER:

Then let us pray and hope that after humanity is slowly wiped of the face of this earth, peace can be found.

Ext. The car getting close. Night.

Scene 19

Fade to car.

JAMES:

Kyle what if this is a hoax what if you killed that bloke back there for no reason what if when we get to the bunker it is empty

KYLE:

Then it's a risk worth taking after all better to be safe than sorry.

JAMES:

Then can't we turn on the radio just to hear if it is a hoax?

KYLE:

I don't want to hear about the imminent missiles, before they hit I want to have hope I'm going to live if I hear one more siren and warning of impact I might not make it to the bunker for fear do you understand.

JAMES:

Yes I do but Nathan needs a hospital

KYLE:

Nathan will make it it's just a flesh wound you said that your self

JAMES:

Yes but it doesn't mean he won't bleed to death he needs medical help

KYLE:

Then fucking help him.

JAMES:

I can't!

KYLE:

Then stop going on about it.

JAMES:

Please let me try the radio

KYLE:

Go for it

He turns the radio on

PRESENTER:

This is an emergency broadcast from the BBC information of a possible nuclear strike has been received the current threat level is critical meaning an attack is imminent civilians are advised to stay in their homes. Evacuations are currently taking place in the London area. All motorways and airports are closed to the public for military use only non-essential telephone lines have also been suspended. Please stand by and await further information.

Warning. Warning… Attack level critical

……warning……….warning…seek

immediate shelter…. Warning. Seek immediate shelter

KYLE:

See I fucking told you now turn it off and help Nathan.

INT. WAR ROOM. NIGHT.

Scene 20

Fade to war room

JIMMY:

Sir what you have done is launch an attack on humanity its self you will kill all humanity for your insane actions.

I am releasing you of your command and placing you under arrest and as such I am duly authorized to sentence you to death you will be tied to a chair and left outside of this bunker you wanted this war then you can have a bloody front row seat!

BRIGADIER CHARLES DAVIS:

You can't do this!

JIMMY:

I think I can see you on the other side prick!

BECKY:

It is too late to call off the attack all we can do is remotely abort once the missiles are launched sir

JIMMY:

Then we will do that I don't want the world to see Britain as the bad guys when all this is over and if we survive, issue all remote detonation codes as soon as they launch.

BECKY:

Understood sir, the codes are already on their way

JIMMY:

Good, right listen up in case of impact you are all to head to

your quarters seal all air vents and begin the oxygen pumps, let us hope the Russians do the same as us an stop this madness before it kills the world.

The room slowly empties and leaves Jimmy and Becky in the room alone. The computers slowly shut off until just Becky's console is running.

Ext. The car pulls up to bunker. Night.

Scene 21

Fade to car pulling up outside the bunker brakes hard locked as the car squeals to a stop.

KYLE:

Nathan, you all right mate?

NATHAN:

Apart from feeling like I need to sleep, I'm all good.

KYLE:

That's good mate we are here.

JAMES:

About time, and talking about time, when are these nukes going to hit?

KYLE:

Forget about that just get inside here's your pass

JAMES:

This says lieutenant Zack aims

KYLE:

Well normal civvies don't get passes idiot we have to pretend that we are what the badges say or we sit here and have front row seats you get me?

JAMES:

All right what about Nathan?

KYLE:

Let me worry about that

JAMES:

You don't have another pass do

you?

KYLE:

No

NATHAN:

Just leave me here guys I have always wanted a front row seat to the end of the world

KYLE:

Are you sure?

JAMES:

Of course he isn't sure he's lost a lot of blood! We are not leaving him here!

NATHAN:

I'm not going to make it anyways

JAMES:

You are you silly sod we are getting you in or I'm not going in!

KYLE:

We don't have time for this get moving.

Ext.　Is this the end?　Night.

Scene 22

Becky is sat down as jimmy paces up and down until a green light appears on the console.

BECKY:

Codes have been successful sent sir all we can do now is to wait and pray.

JIMMY:

Understood

BECKY:

Launch detected sirand anotherand three more Make that tenNo fortySir I don't think Russia have realized we have stood down sir!

JIMMY:

OK corporal; stand down phone your family this is your last chance to say good-bye.

BECKY:

Well if this is the last few moments of my life I don't want to spend them crying to my family.

Becky kisses Jimmy and begins to undo her shirt

JIMMY:

Corporal this is not how I thought I'd spend my last moments

BECKY:

You don't want to and please call me Becky

JIMMY:

Of course I do, I'm just not sure I should take advantage of you

BECKY:

Who said you would be taking advantage of me.

Becky pushes jimmy to the floor behind the desk the camera sees Becky from the chest up she takes off her top to reveal her bra then disappears from sight below the desk.

Int. Safety at last. Night.

Scene 23

They approach the two guards at the door show them the two passes the guards don't check for a third pass as they notice Nathan is injured and they rush him inside.

 KYLE:

We are safe shut the door

 JAMES:

What about the public?

KYLE:

It's too late to do anything

JAMES:

No we have to do something we can't just leave them

KYLE:

What would you have us do open that door and risk our lives we don't know when the impact is it's not worth the risk

JAMES:

My life isn't more valuable than any one of those people out there I won't stand by and do nothing.

KYLE:

Then go but the moment you open that door you will not be coming back in here understood?

JAMES:

Who died and made you king of the bunker

KYLE:

Well no one but someone needs to lead us through this

JAMES:

What in the world makes you think you could lead us through this?

KYLE:

Well I don't see you doing any better

Nathan gets treated by the guards and limps through the old museum in the front of the bunker. He finds an old Russian NBC SUIT (nuclear biological chemical warfare suit) and he put it on to have a joke with the others.

JAMES:

I don't think I can stand by and watch you, while there are hundreds of people we can save

KYLE:

Tapping the gun on his forehead

Look I don't like it any more than you, but if we let them in what's to say any of them aren't Russian spies?

JAMES:

Are you kidding me they are about to nuke us why would they have their own people here

KYLE:

I don't know because they would need to know key targets like this

JAMES:

Good point, but that's a risk worth taking to save hundreds of people

Nathan burst through the door

NATHAN:

Privet milym damam!
(Russian) Hello pretty ladies!

Kyle doesn't think twice and runs at Nathan tackling him to the ground before putting a bullet between his eyes

KYLE:

See what I mean

JAMES:

Where's Nathan

KYLE:

Out there, with the guards

As he says that the guards run in after hearing the gunshot

GUARDS:

Put the gun down

KYLE:

I just killed a Russian

GUARD 1:

Yes a Russian from World War 2

KYLE:

Who is this then?

GUARD 2:

Well as you were the first and only three to get here and me him you and your mate are here that only leaves one person it could be

JAMES:

No it can't

James runs over to the motionless body removes the mask and clutches him. James rocks slowly back and forth with Nathan in his arms he kisses him on the lips.

JAMES:

Nathan I never got to tell you I love you

He turns to Kyle

You killed Nathan you stupid fuck!

KYLE:

No, but, I thought he was a Russian spy.

JAMES:

You may be the dumbest smart guy I know, there isn't any Russians here, and this stupid attack hasn't happened, even though you said it was, well guess what I have been with you all day

travelled to god knows where and you have now killed two people. You're insane I will prove this attack isn't real; I'm going out there you can stay in this cocoon. But I'm not this is over.

James gets up walks towards the door

GUARD 1:

That's not a good idea the threat is very real

JAMES:

Then why isn't anyone else here?

GUARD 2:

This bunker was reserved for the prime minister and his personal protection crew, which I'm guessing your impersonating.

JAMES:

Then where is the prime minister?

GUARD 1:

After we went nuclear the prime minister was diverted to a

European allies bunker, with his personal guard special agent Sofia walker.

KYLE:

Did you just say Sofia walker?

GUARD 1:

That's what I said, are you deaf?

KYLE:

She's alive; thank god she's alive

GUARD 1:

Who is she your sister?

KYLE:

No, why does everyone seem to think that I'm related to her and not that I'm dating her, she's my girlfriend!

JAMES:

Look I don't care; I'm not staying here not with you.

James opens the door and people

start pouring in James is trapped by the door and there is a faint whistle heard as just in shot through the door a white trail leading to earth, can be seen in the sky.

KYLE:

Shut the fucking door shut the door quickly, quickly!!!!

JAMES:

I can't its jammed

KYLE:

Hurry up!

JAMES:

It's not going to work, it won't budge.

The door is trapped by a brick that fell in the rush the camera can see it; the camera zooms in and fades slowly

Ext. credits.

FIN

www.ingramcontent.com/pod-product-compliance
Lightning Source LLC
Chambersburg PA
CBHW070426180526
45158CB00017B/771